ABOUT THE BOOK

This comic book is about two brothers who wanted to be famous. However, they only had one chance to perform at an old theater down the street. So, the brothers worked together to sell tickets for their showcase and sold out! It may be their moment to shine!

Will they become famous?

DEDICATION

I would like to dedicate this book to my mom for always believing in me. I would also like to dedicate this book to my teacher MsC, and Mission Completed Animation.

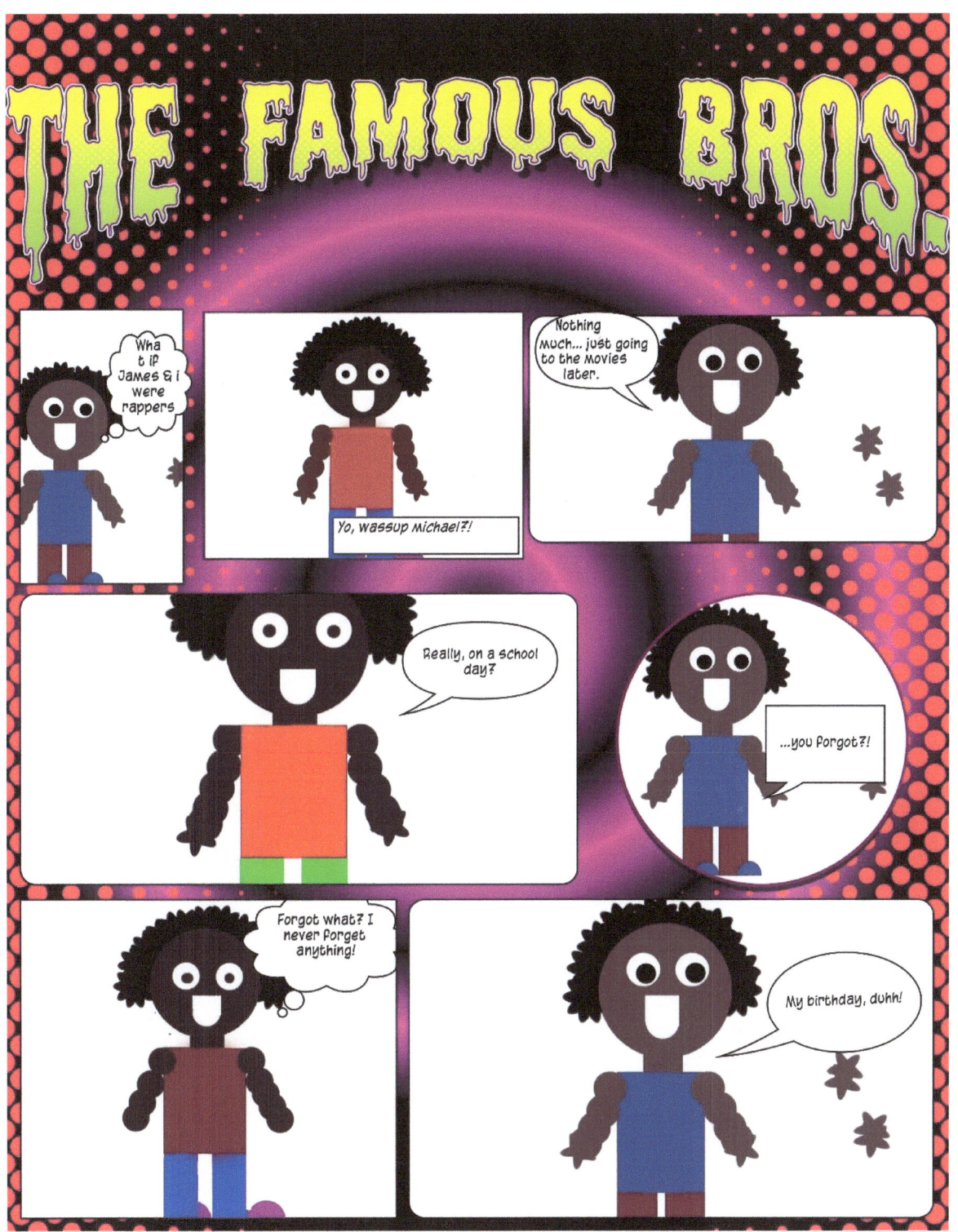

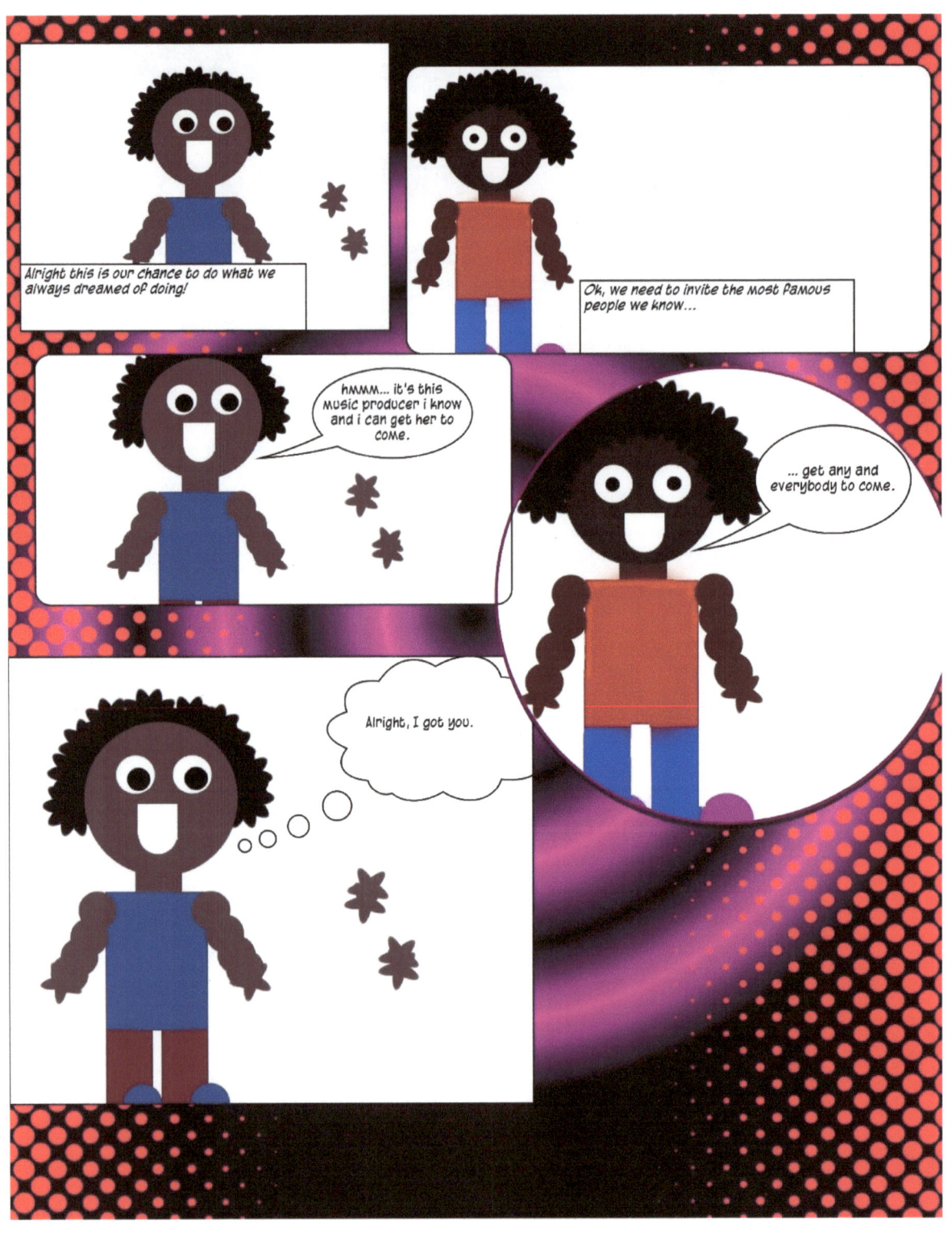

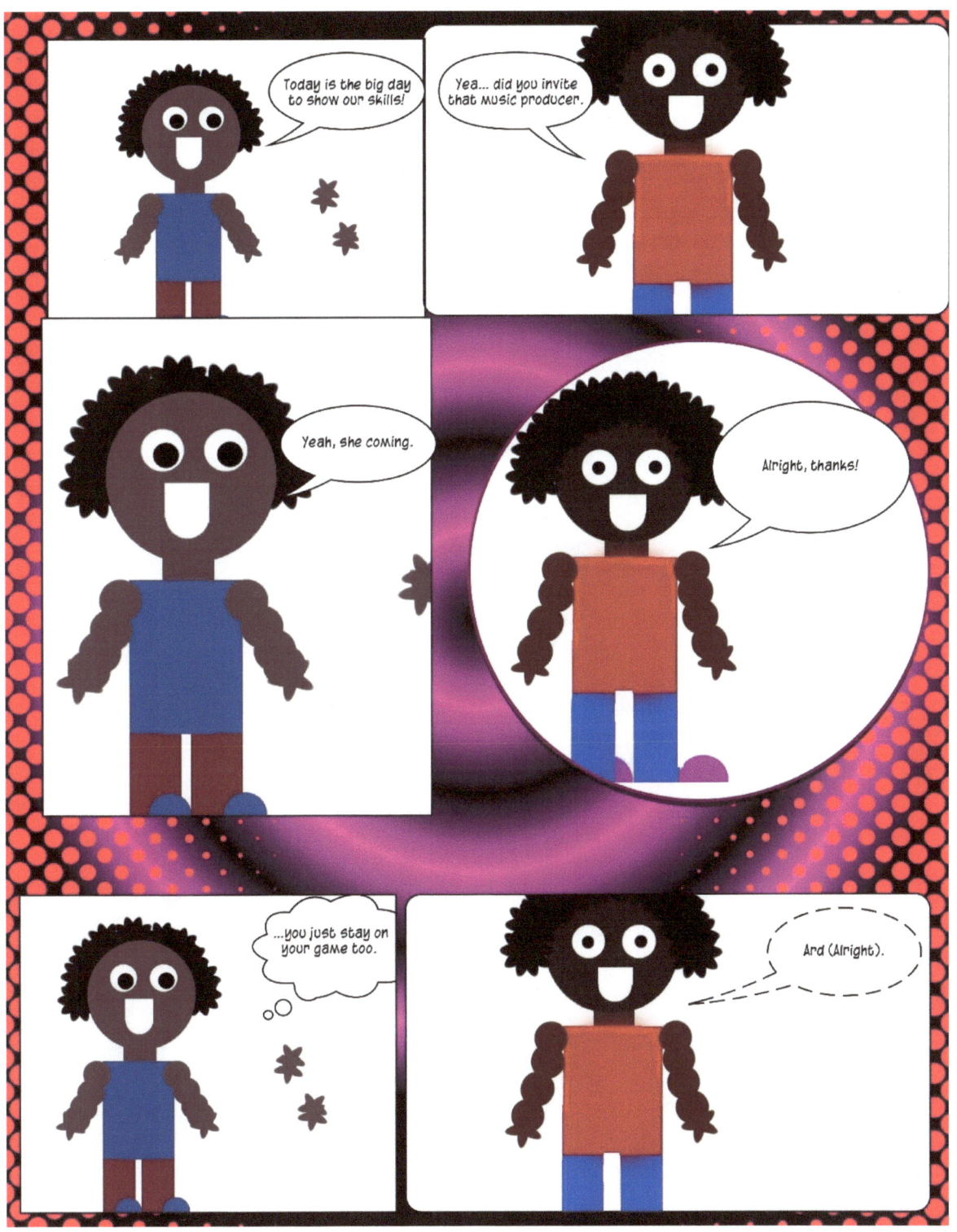

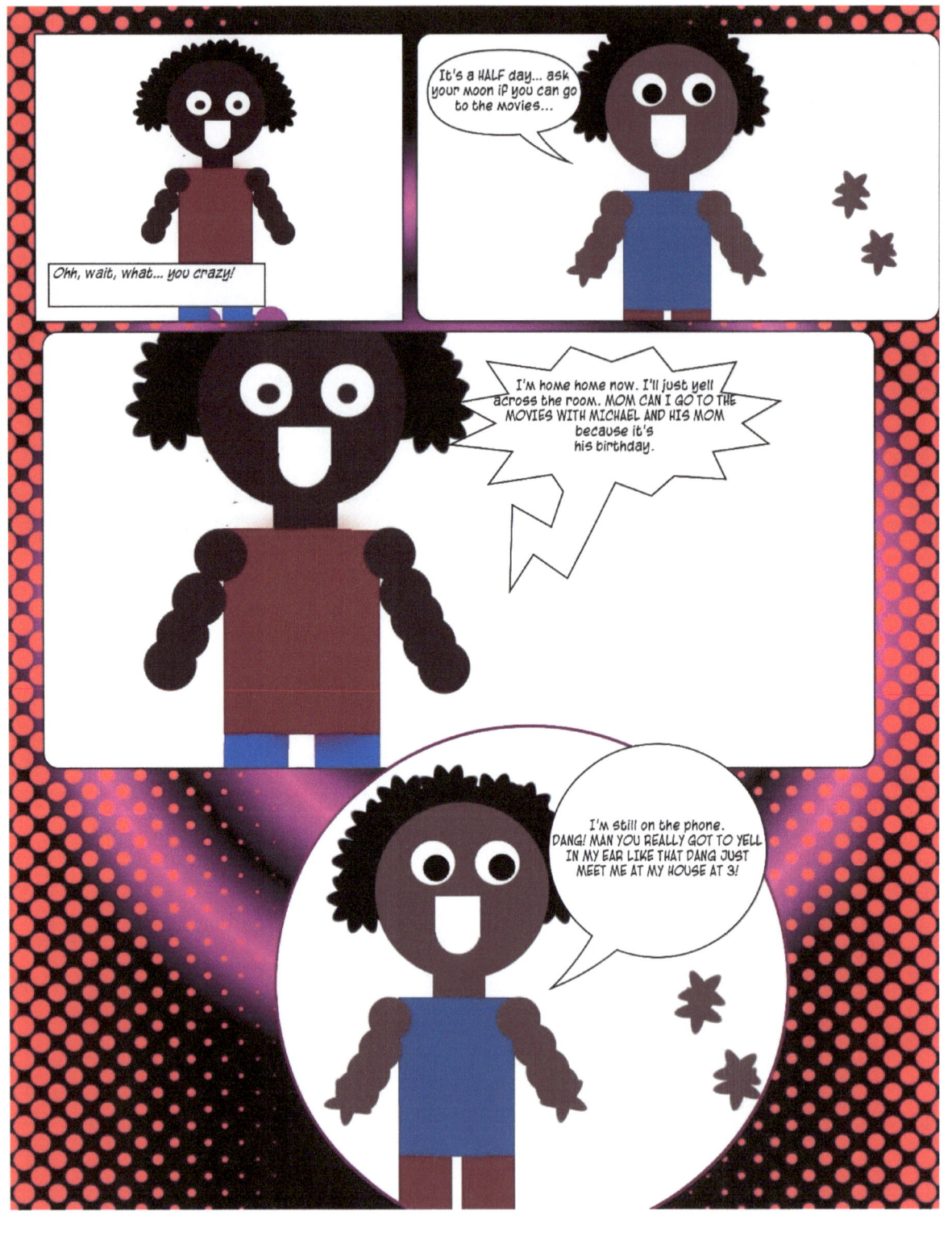

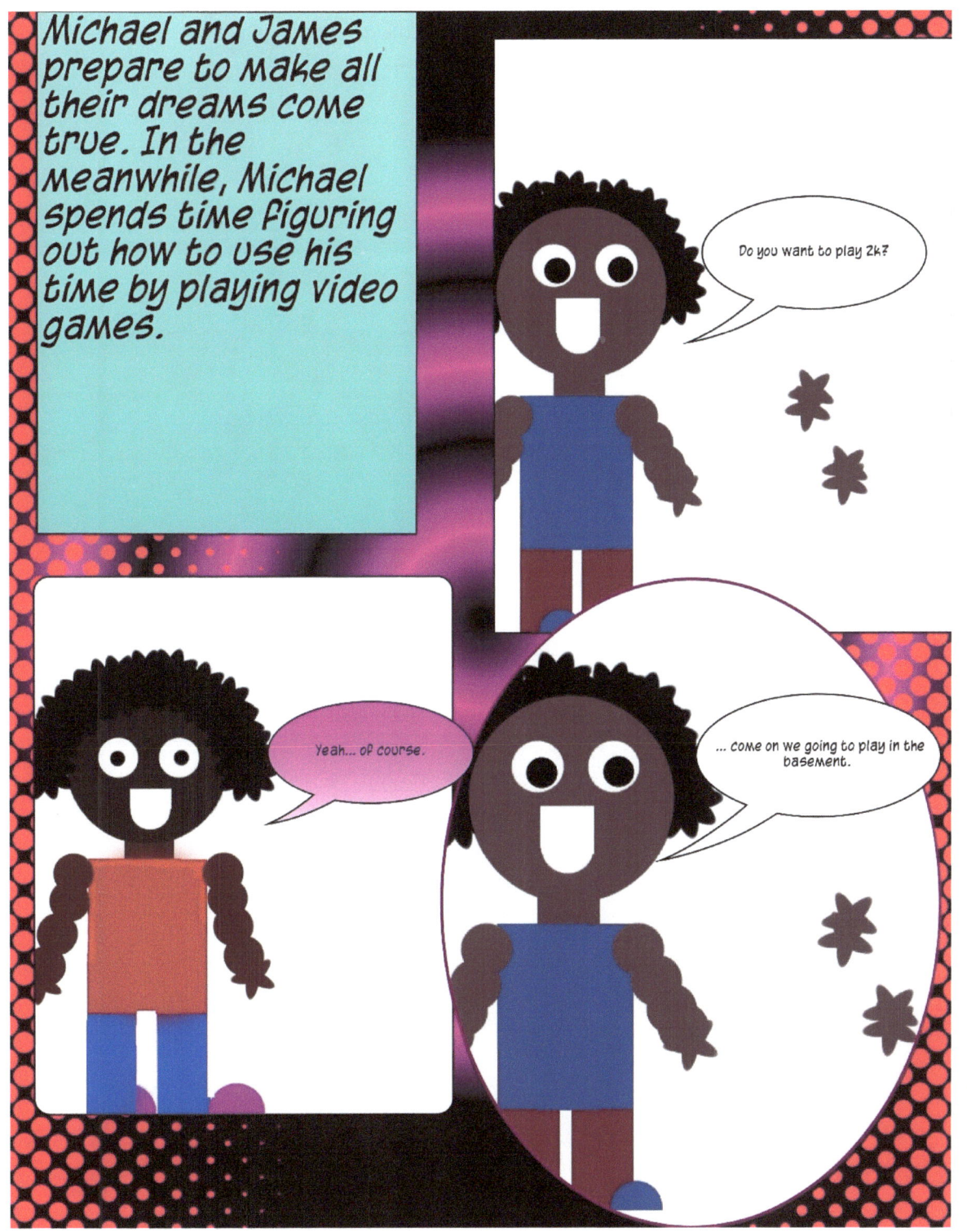

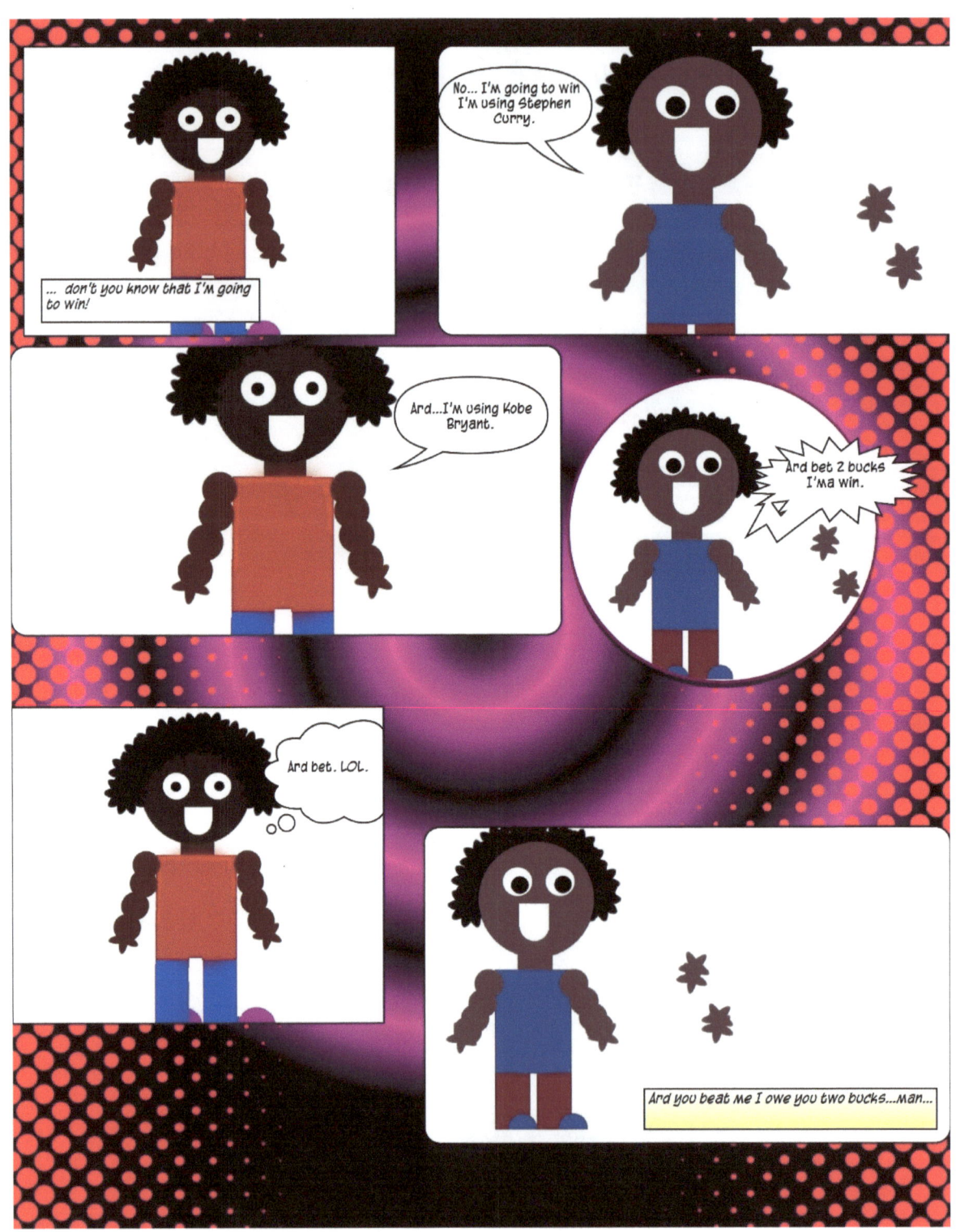

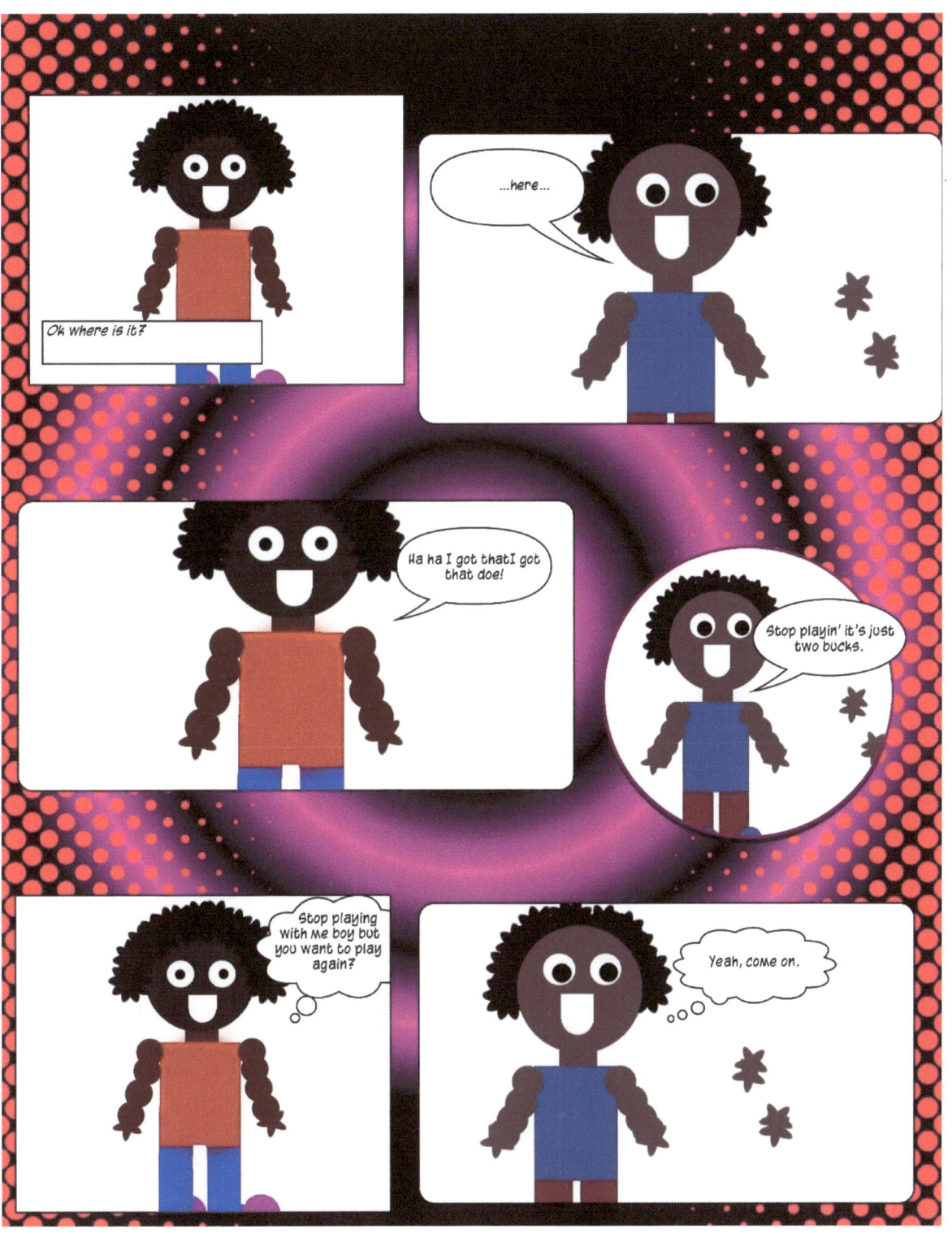

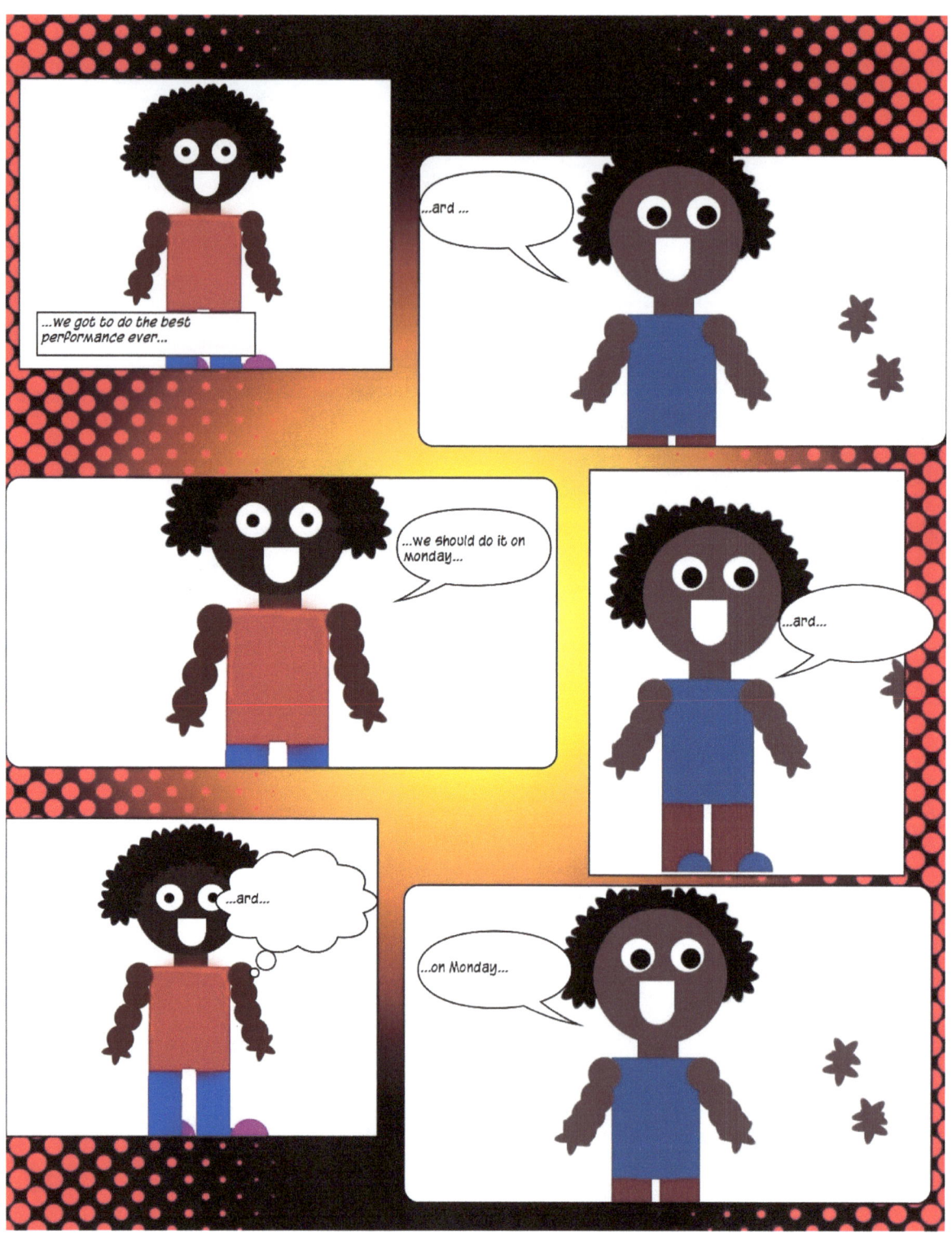

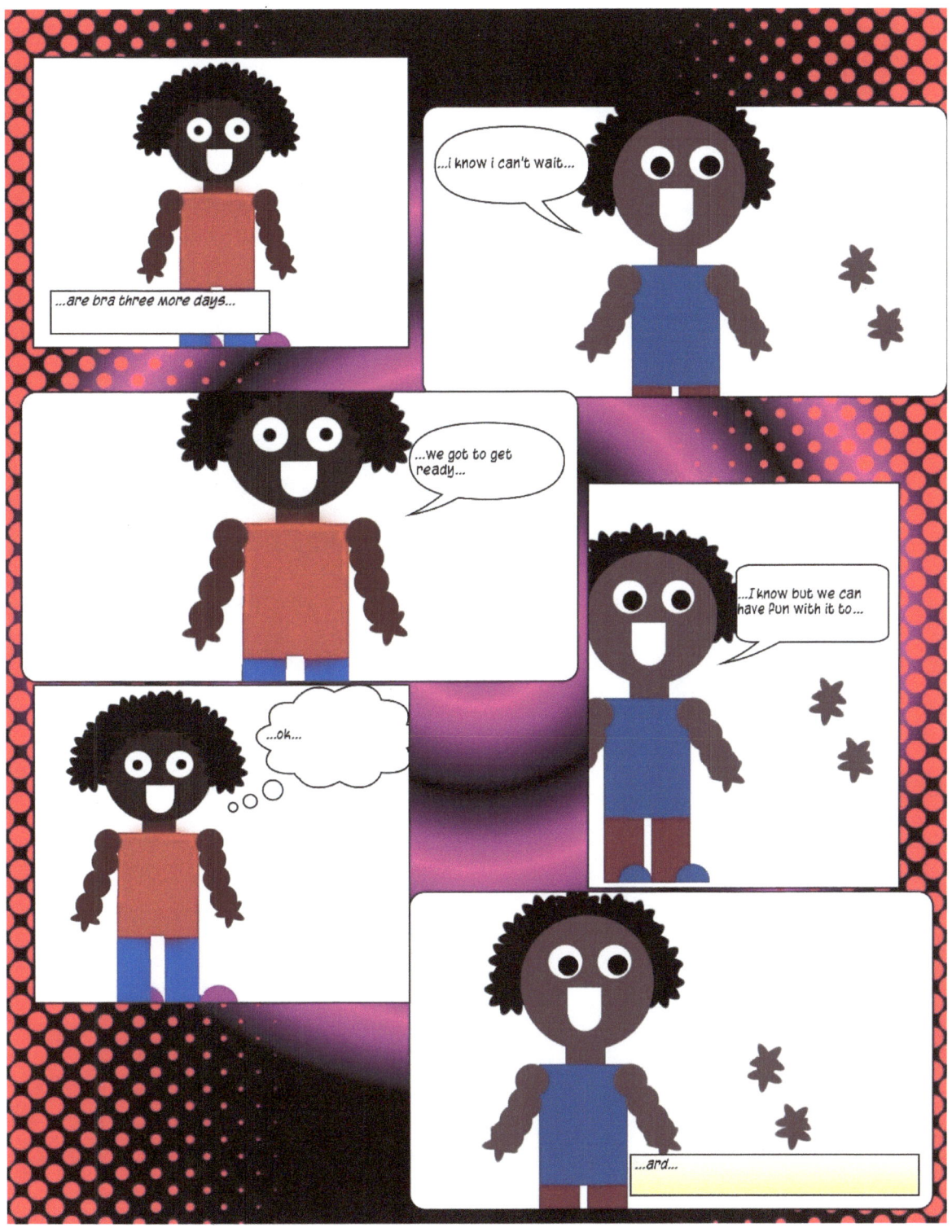

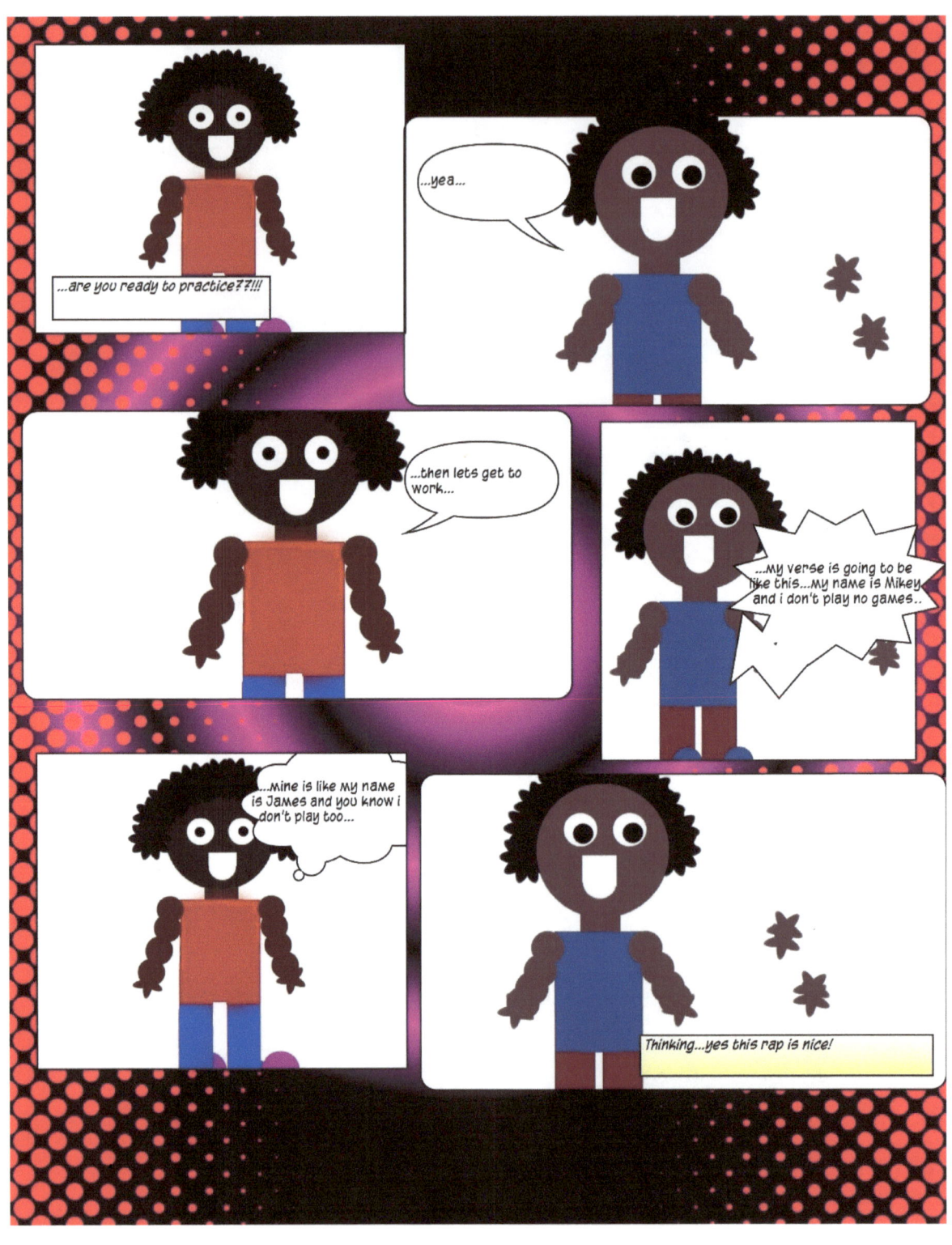

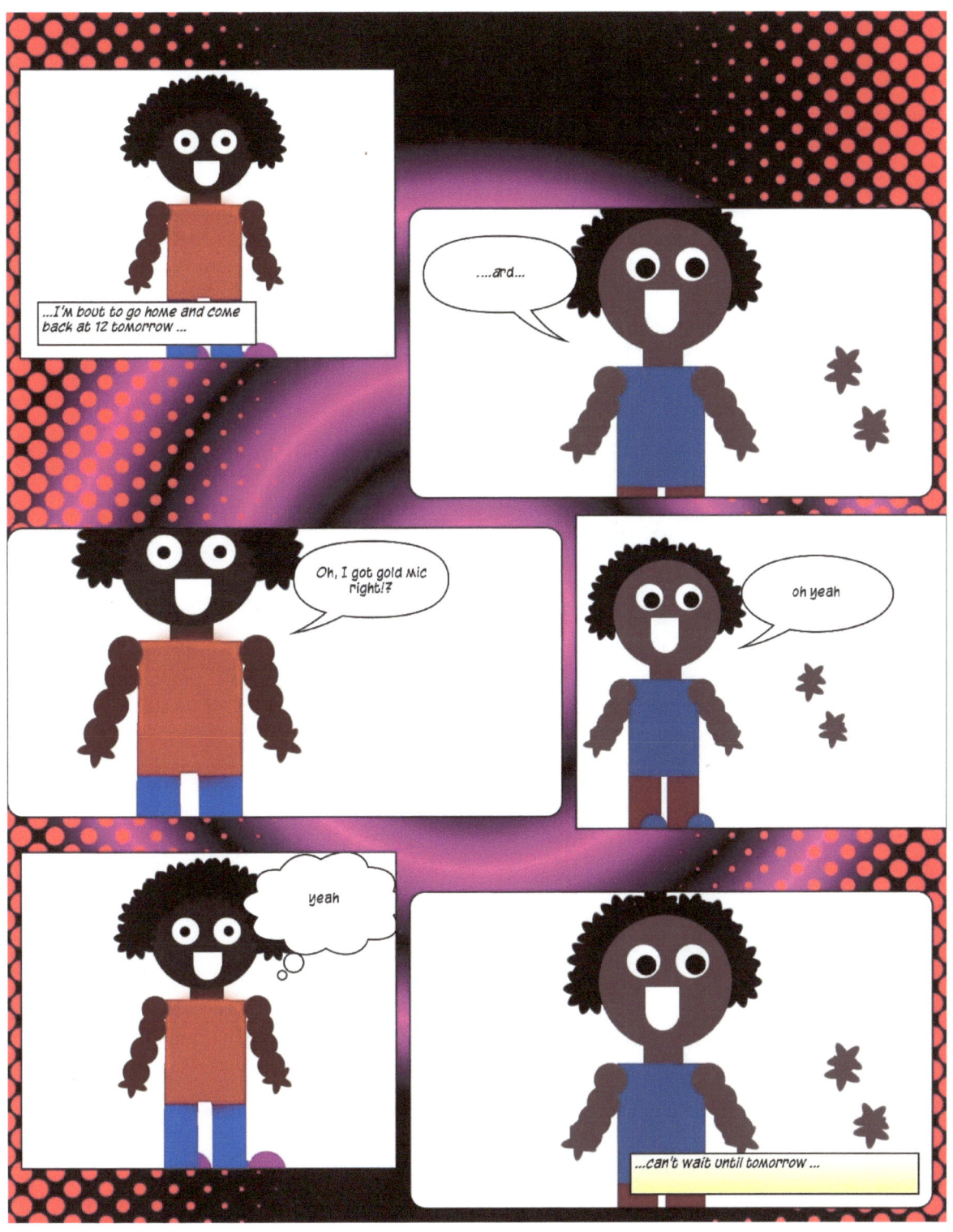

CREDITS

Michael Poindexter created all illustrations and written content.

© 2016 Michael Poindexter. All Rights Reserved.

www.ingramcontent.com/pod-product-compliance
Lightning Source LLC
Chambersburg PA
CBHW050410180526
45159CB00005B/2213